INTERIORS
STYLED BY
Mieke ten Have

MIEKE ten HAVE

PRINCIPAL PHOTOGRAPHY
BY FRANK FRANCES

INTERIORS
STYLED BY
Mieke ten Have

VENDOME

NEW YORK · LONDON

CONTE

INTRODUCTION

"WHAT WOULD YOU LIKE FROM THIS ROOM?"

I was at most ten years old when my grandmother asked me this question. We were standing in her Federal-style dining room, which is the first room I ever fell in love with. What I wanted to say was, "Everything," but I replied, "The curtains." She laughed.

I still return to her house, especially her dining room, in my dreams. The walls were covered in Zuber's Vues d'Amérique du Nord panoramic paper, the curtains were canary-yellow damask, and every surface—demilune table, sideboard, scrolled-shell-topped corner cupboard—was filled with objects. The jasperware, export ware, Steuben, American glass, bronze candelabras, and Meissen were arranged like talismans at a shrine to the decorative. She was a fabulous hoarder. The panoramic wallpaper had a surrealist quality that prompted me to imagine a world beyond the confines of the walls that held it; I was curious about it all, and it seemed to reveal something new every time I walked in the door.

I often think of the question she asked me, as it is revealing; I couldn't specify one thing, because in truth, what I really wanted was the entire feeling the room conveyed. It was the sum of its curious parts that held my imagination.

Thus, my fascination with interior worlds started when I was a little girl, captivated by and inquisitive about the emotions certain places stirred up in me. It took shape in various forms: during ennui-filled summers spent in Maine I became intrigued by architecture in disarray—the duality of the order and decay of dilapidated Colonial-era vernacular houses was a spectacular foil to my family's chintz-laden Manhattan apartment. I loved the mysterious inner tombs at the Metropolitan Museum's Egyptian

OPPOSITE: Polaroids my grandmother took of vignettes in her dining room in the 1960s.

wing with their unintelligible stories carved in stone (I loved visiting the temples of Abu Simbel even more). I was lucky to travel young; it gave me an appreciation for what my father calls "looking at old stones." The broken-down baroque architecture of Naples and Sicily cast a kind of spell on me, while the crooked lines of the canal houses in my father's hometown, Amsterdam, made me want to swap my New York childhood for a Dutch one. The Romanesque abbeys of France so moved me that I fancied I must have been a monk (likely a wayward one) in a previous life. I gravitated toward places with elements that seemed at odds with each other, revealing a tension both novel and exciting.

My favorite book as a child, which in retrospect had an outsize impact on my path, was Min Hogg's 1988 edition of *Interiors: The Eight Major Decorating Styles Seen in Today's Most Beautiful Rooms*. I ceaselessly studied those rooms, filled with collections of oddities and colors and textures. My mother had a similar knack for crafting beautiful tableaux in our East 66th Street living room. On bookshelves painted a creamy matte citrine, Grand Tour bibelots mingled with dainty portrait miniatures; idol-like enamel snuffboxes sat against a backdrop of Neapolitan gouaches of crisp blue skies, a foreboding Vesuvius fuming in the distance. She was effortlessly able to orchestrate vignettes that summoned curiosity.

All these points of interest from childhood—and the exquisite joy at the simple act of looking that they elicited—funneled me into a career in interiors. I found my path as a magazine editor, working at places like *Elle Decor* and *Vogue*. That work trained me to think of rooms as stories and how to capture the feeling of a place or even an object and its integrity within the confines of a photograph. An image might seem to diminish the impact of an interior or an object but can paradoxically expand it; it is a way of distilling a truth or an emotion of a place or thing in one click of the shutter.

As a stylist, a career I came to frankly inadvertently, I marvel at the good fortune I have had to work with some of the most talented design luminaries. This book is an homage to the designers and photographers I am lucky enough to collaborate with to create these beautiful pictures. I think the term *stylist* is a nebulous and often confusing one. What I'd rather tell people is that I am a storyteller of sorts, always seeking to conjure emotion in rooms using objects, flowers, colors, and patterns as my tools. To that end, I devote the first part of the book, "4 Principles," to the fundamentals that underpin my styling work: "Color Theory," "Pattern Play," "Wild & Tame," and "Flowers for Living." Illustrated with photographs of rooms that I have styled in collaboration with some of the world's leading interior designers, the first part shows you how to think about using these principles in your own home. Unsurprisingly, these elements often overlap and intersect, so in the second part, "4 Seasons," I demonstrate how I apply these interwoven styling principles in my home in the country—the Barn—over the course of a year.

Though the Barn is the home I share with my husband and two children, it is also still a working barn, albeit no longer for livestock or wheat; it is my laboratory and canvas. In it, I bring to bear all my experiences and interests: collecting and arranging, pattern laying and layering, exploring color concepts, and indulging in the ever-changing landscape around me, the bounty of which I bring into my home year-round. The evolution of the Barn is a bit like a rambling, ever-changing love story with many chapters still to come.

I wrote this book to explain my way of seeing, and what I personally delight in, for that's what interiors are all about, I think. So what would you like from your rooms? These are the spaces in which you live your life, after all. I hope this book helps you consider this simple but wonderful question.

MIEKE ten HAVE

APRIL

Color THEORY

I'm promiscuous when it comes to color—I am a lover of many, but most especially of titillating color combinations. Little is more powerful than the use of color to transform and envelop. Yet color is a very polarizing medium; there's no accounting for personal preference, and as in all things, I advocate following what you love. There's a lot of fear surrounding the use of non-neutral colors; a solid vigorous color can overwhelm, whereas a solid sedate color can bore—the worst outcome of all!

A color's success in a room is often predicated on what it is coupled with; styling with the right colors can be very impactful. Adding secondary and tertiary hues, usually from other color families, can not only paradoxically amplify the primary color but also, more importantly, generate a dialogue between them that enlivens a room and spares it from monotony.

OPPOSITE: To style this room in a Manhattan duplex—late interior designer Mario Buatta's final project—I took my color cues from Buatta's signature curtain treatment and the homeowner's Magritte. *PHOTOGRAPHER:* Scott Frances

OVERLEAF: In the home of John-Mark Horton, a former monastery perched on a seaside cliff above Roquebrune-Cap-Martin, France, the nineteenth-century hand-painted English wallpaper is a showstopper. I used a blanket that picked up the colors of the scenic so as not to detract from it. A foraged flower arrangement blurs the lines between reality and mural. *PHOTOGRAPHER:* Ricardo Labougle

"COLOR IS THE PLACE WHERE OUR BRAIN AND THE UNIVERSE MEET."

—PAUL KLEE

The trick is to pick secondary colors that are of a similar intensity, so they are matching in vigor and can hold their own weight. In a bedroom designed by Ellen Hamilton in Windsor, Florida (see facing page), for instance, multiple shades of green, from chartreuse to moss and lime, cover the walls and bed. Splashes of red in the artwork and the rug provide contrast, and the addition of an indigo ombré blanket not only animates the mélange of greens but also contrasts with the secondary red accents. The vigor of the indigo proves to be a strong dueling partner for the greens, and that combination electrifies the room.

When a room is deliberately designed in a single color, however, with few, if any, contrasting colors, I preserve its integrity through my styling choices. Adding a secondary accent color would only serve to detract. A monochromatic room must be leaned into, allowing its textures, finishes, and silhouettes to reveal themselves. In the case of a Brooklyn kitchen designed by Billy Cotton (see page 30), for example, Farrow & Ball's Bone White prevails, with only a dappling of hazelnut-and-white checks, copper pots, and a cream-and-chocolate French porcelain service. By adding only an all-white arrangement of ranunculus and lilacs in a white ceramic basket, flanked by two Italian white porcelain candelabras, I maintained the holistically immersive feeling of the room; the eye doesn't linger on any one thing, but rather on the varying textures of the high-gloss walls, the shiny checkered-chintz fabric, the smooth yet textural floor, and the glistening chandelier. The room embraces you in its totality, and the mono-chromatic styling accessories enhance that experience.

OPPOSITE: A bedroom in Windsor, Florida, designed by Ellen Hamilton.
PHOTOGRAPHER: Thomas Loof

OPPOSITE: A tented dining room in a Park Avenue apartment designed by Josh Greene is an exercise in seductive tonality.
PHOTOGRAPHER: Tim Lenz

OVERLEAF LEFT: In the fabulous, color-blocked foyer designed by Stephen Sills for Wes Gordon and Paul Arnhold, I arranged masses of yellow tree peonies in glassblower Arnhold's own vessels.
PHOTOGRAPHER: Stephen Kent Johnson

OVERLEAF RIGHT: In designer Sara Story's dining room, the jewel tones in the Kati Heck painting leap from the artwork into the arrangements of exuberant dahlias and sweet pea vines on the table.
PHOTOGRAPHER: Joshua McHugh

"MERE COLOR, UNSPOILED BY MEANING, AND UNALLIED WITH DEFINITE FORM, CAN SPEAK TO THE SOUL IN A THOUSAND DIFFERENT WAYS."

—OSCAR WILDE

OPPOSITE: Leaning into color in Sara Story's home.
PHOTOGRAPHER: Joshua McHugh

OVERLEAF LEFT: The monochromatic Brooklyn kitchen designed by Billy Cotton for Lily Allen and David Harbour.
PHOTOGRAPHER: Simon Watson

OVERLEAF RIGHT: In the Brooklyn home of Suleika Jaouad and Jon Batiste, designed by Hallie Goodman, the flowers are a living simulacrum of the antique chinoiserie screen behind the guest-room bed; the pillow brings out both the deep and the blush tones in the screen and florals.
PHOTOGRAPHER: Frank Frances

OPPOSITE: Hits of neon orange in the stick lampshade and roses speak to the artwork above the desk but, more importantly, energize and modernize the classical Zuber wallcovering in a gorgeous living room designed by Billy Cotton for Lily Allen and David Harbour.
PHOTOGRAPHER: Simon Watson

OVERLEAF LEFT: Emerald pressed glassware and fuchsia bougainvillea are an unexpected contrast to the blue-and-white Portuguese scenic tiles that line the walls of a loggia in Ibiza, Spain, designed by the Alberto Pinto Agency.
PHOTOGRAPHER: James Merrell

OVERLEAF RIGHT: In the house in Castine, Maine, where Robert Lowell wrote much poetry and had a tortured love affair with Elizabeth Hardwick, designer Stefanie Scheer Young used rich colors in the series of front rooms, creating a dynamic enfilade effect. I pulled those colors together with a lusciously hued ikat textile—a departure from the more traditional furnishings. A lapis lazuli–blue sculpture in the shape of coral (another departure from the decorative tenor of the room) was not only the perfect color foil to the café au lait walls but also accentuated the color story in the adjacent rooms. And yes, I wanted the candles crooked.
PHOTOGRAPHER: Read McKendree

"HUMANS ARE PATTERN-SEEKING CREATURES."

—KEHINDE WILEY

Pattern PLAY

An interesting, successful room is one in dialogue with itself. Deploying various patterns within a space can reveal more about the room and the objects in it than a blank canvas ever could. It is in conversation and juxtaposition that things show their true nature, whether it be fabric, antiques, or art. I think of using patterns in two ways: literally, as in the patterns in textiles, wallcoverings, and rugs, and conceptually, as in collections or themes created by the grouping or placement of either similar or diverse objects, artwork, and shapes.

What binds these two disparate ideas is the way in which patterns move the eye about the room, imbuing it with liveliness and dynamism. Patterns have the capacity to bring an interior to life.

In styling or designing with decorative surface patterns, I gravitate toward combining varying scales and provenance. In the guest bedroom of Deborah Needleman's Garrison, New York, home (see facing page), for example, designer Rita Konig punctuates walls clad in a classic black-and-white

OPPOSITE: Deborah Needleman's guest bedroom, designed by Rita Konig.
PHOTOGRAPHER: Miguel Flores-Vianna

OVERLEAF: In the dining room of architect Nate McBride and designer Kari McCabe's splendid eighteenth-century summer home in Connecticut, I reoriented the dining table to catch a glimpse of the yellow hallway behind it and the green front door, both of which accentuate the Josef Frank wallpaper. A geometrically patterned Swedish rug on the table serves as a graphic foil to the floral wallpaper, while picking up its color palette for cohesion.
PHOTOGRAPHER: Read McKendree

"NO PATTERN SHOULD
BE WITHOUT SOME SORT
OF MEANING."

—**WILLIAM MORRIS**

toile de Jouy with a ruby-red lamp and an amethyst-purple shade. Taking color cues from this rich combination, I covered the bed in graphic and variously scaled textiles: a classic American red-and-white quilt, a predominantly red kantha blanket, and dainty French floral-print pillowcases. A graphic Turkish kilim on the floor converses with the pattern of the quilt above it and is a fantastic departure in scale from the dense and florid toile on the walls. A painting I hung on the wall to one side of the bed incorporates all the various hues, like an abstract color chart for the room. In this riotous combination, I believe the integrity of each element remains intact; instead of layers melding into one another, each article has its own identity and role. I also love initiating a conversation between various textile traditions: the French printed toile de Jouy, the homespun American quilt, and the woven Turkish kilim. Each is distinctive in its coupling with counterparts from other cultures. I wonder what fascinating stories they are telling each other.

In a Wisconsin breakfast room designed by Jessica Jubelirer (see page 43), a dense Fortuny fabric lines the ceiling and a small-scale Claremont fabric covers the walls. An arrangement of white lattice plates and white ceramic sconces on the wall beneath an amorphous white wood sculpture by Philippe Anthonioz is a quietly striking focal point. The overall pattern of the room, for me, was *dentelle* (French lace) come to life—so beautifully intricate but pure and simple. The refined white ceramic of the plates and light fixtures, the custom passementerie of the curtains, and the curlicue line suspending the ceiling fixture are proof of concept. I wanted to pay homage to that subtle patterning in styling the room, so I introduced a mélange of delicate, white-glazed black terra-cotta ceramics from Astier de Villatte, white majolica pots with rustic but precious painted patterns, and an arrangement of lacy snow-on-the-mountain euphorbia. The ceramics on the table and the ethereal white arrangement were an extension of the pattern concept throughout the room.

There is a power in leaning into the repetition of a pattern, whether it be in textiles or a collection of objects. It is much like a through line of a story, engaging you and holding your attention.

OPPOSITE: A mélange of patterns of various origins are in delightful contrast to textile designer Schuyler Samperton's own wallpaper.
PHOTOGRAPHER: Annie Schlechter

ABOVE: At the Lyford Cay, Bahamas, home of Lulu de Kwiatkowski, I scoured her collection of Imari porcelain, candelabras, and various diminutive *objets* to create a small-scale fantasy. Wild elements from nature—seashells collected from the local beach, bougainvillea from her backyard—mingle with Italian silver and fine linen.
PHOTOGRAPHER: Pernille Loof

OPPOSITE: A delicately patterned breakfast room in a Wisconsin home, designed by Jessica Jubelirer.
PHOTOGRAPHER: Douglas Friedman

OVERLEAF: In this Manhattan bedroom, designer Ellen Hamilton confidently deploys a diverse array of textiles and colors and somehow marries them beautifully. The Viso tapestry over the headboard blends with Turkish, French, and Indian textiles of varying scale on the bed; rich paisleys speak to each other across the room. The vivid blue walls are a strong backdrop, against which colors of equal weight pop. A harlequin-like poster by David Hockney for the Metropolitan Opera ties in all the hues in the room.
PHOTOGRAPHER: William Abranowicz

PRECEDING PAGES LEFT: In Susan Crater's study, a vivid tangerine beautifully duels with fabric designed by Eliza Harris for Sister Parish. A geometric Gregory Parkinson blanket over the chair bridges the wall color, florals, and textiles.
PHOTOGRAPHER: Read McKendree

PRECEDING PAGES RIGHT: In the former bedroom of antiques dealers Dana and Fritz Rohn in Salisbury, Connecticut, the sophisticated blue-and-white pattern play brilliantly leaps from textiles and upholstery to Delft and Chinese pottery.
PHOTOGRAPHER: Dean Hearne

ABOVE: Stripes, florals, and geometric patterns converge in this summer house in Gloucester, Massachusetts, by Reath Design.
PHOTOGRAPHER: Laure Joliet

OPPOSITE: A guest bedroom in John Demsey's Manhattan townhouse is filled with paintings by his mother. The vigorous mélange of patterns is grounded by the black-and-white wallpaper. Jubilant red anemones, with their black-and-white pistils, echo this patterning.
PHOTOGRAPHER: Douglas Friedman

"I WISH I WERE A GIRL AGAIN, HALF SAVAGE AND HARDY, AND FREE."

—EMILY BRONTË

Wild & TAME

For as long as the decorative arts have existed, we human creatures have had a need to bring the natural world inside. Flowers and wilderness motifs in tapestry, artwork, and other surface design have long preserved the fleeting months of spring and summer and served as an allegory for time's impermanence. Personally, I carry a pair of shears in my car and often in my purse, in case I happen upon a weed or a branch that I simply must bring home. In each space I touch, I try to foster a dialogue between that which is civilized and tame and that which is wild and uncontrolled. Interesting spaces revel in this duality. Harnessing oppositional elements breaks down the barrier between inside and out, and introducing elements out of context delights the eye.

In a New England estate, architects Ferguson & Shamamian conjured up a formal, classical house in the style for which they are renowned, boasting no shortage of elaborate crown moldings and Doric pilasters. A peek into the grand living room designed by Tino Zervudachi illustrates the point, albeit

OPPOSITE: A section of the living room in a formal house designed by Ferguson & Shamamian, with interiors by Tino Zervudachi.
PHOTOGRAPHER: Thomas Loof

OVERLEAF: For the dining room of a Brooklyn townhouse designed by Carrier and Company, I cut a rambling, whimsical, and towering branch from the backyard. It both echoes the refinement of the de Gournay wallpaper and brings the tree line into the room.
PHOTOGRAPHER: Sam Frost

"WILDNESS IS A NECESSITY."

—JOHN MUIR

in dramatic fashion (see page 51). No matter how beautifully done, a formal room, especially one predicated on symmetry, pleads to be disrupted. To act as a counterpoint to the room's stately ambience, I foraged some rambling, sculptural, and, most importantly, wild-looking pokeweed, one of my favorite invasive species to cut down and bring inside. It's fantastically structured, like a set of horns emerging from the ground, sprouting aubergine- and crimson-colored berries and exuberant emerald leaves. At the shoot of this particular estate, we were lucky to have a fabulous living, breathing, and beautiful prop—a horse from the stables, peeking her noble head and billowy mane into the sedate and cultivated scene.

This fortuitous moment illustrates in a dramatic way the dazzling effect that a bit of wildness can have on a tame and formal interior setting. Introducing a wild element is one of the simplest of styling tricks to energize a room and, happily, such elements can be found anywhere, often at no cost. I am always enchanted by the array of beautiful roadside weeds in countless colors, shapes, and sizes that crop up without human intervention from spring until first frost. Pay attention to these unsung treasures; they can impart so much surprise and originality to a home. A freshly cut tree branch can double as a living sculpture; its stately power impacts the sense of scale and order in any room.

PRECEDING PAGES LEFT: In the atmospheric dining room of photographer Ari Kellerman's seventeenth-century house in Maine, a riotous arrangement invigorates the mood of the room, while a tapestry fragment over the table adds a sensuous touch.
PHOTOGRAPHER: Ari Kellerman for *Cabana* magazine

PRECEDING PAGES RIGHT: In this sophisticated loft designed by Jessica Schuster, a wild, cascading, and oversize arrangement disrupts and softens the symmetry of the sideboard and flanking chairs.
PHOTOGRAPHER: Douglas Friedman

OPPOSITE: For an outdoor table installation at the Virginia farm of ceramic artist Laird Gough, I foraged shockingly vivid azalea branches and white dogwood and mixed Gough's beautiful pots with fine silver and formal linens, resulting in a setting that embodies the tension of spring.
PHOTOGRAPHER: Kelli Boyd

OVERLEAF LEFT: A ceramic monkey serves breakfast with a side of bougainvillea in Lulu de Kwiatkowski's Lyford Cay kitchen. Freshly cut coconuts came from the palms outside.
PHOTOGRAPHER: Pernille Loof

OVERLEAF RIGHT: In the Brooklyn backyard of fashion designer Ulla Johnson, I wanted the tablescape, which features a collection she collaborated on with *Cabana*, to reflect the romantic garden surrounding it.
PHOTOGRAPHER: Brett Warren

ABOVE: The hills are alive with wild-looking cosmos in a room designed by Sheila Bridges. I always like to tease a surrealist touch out of scenic wallpaper.

PHOTOGRAPHER: Frank Frances

OPPOSITE: In this elegant country dining room designed by Virginia Tupker, I mixed verbena with white asters and arranged them explosively in an earthenware bowl to both echo and offset the chandelier overhead. A dappling of plates loosely scattered—and not all matching—tousles the space ever so slightly.

PHOTOGRAPHER: Isabel Parra

OVERLEAF: A garden-party table setting I created for designer Mary Taylor McGee at a Palm Beach house by architect Marion Sims Wyeth.

PHOTOGRAPHER: James McDonald

Conversely, I urge the intrepid aesthete to civilize something wild. One of my favorite things to do is entertain in a field, using not a trace of plastic or anything disposable. Rather, I delight in bringing a dining table outdoors, covering it in a beautiful fabric, and setting my best china, silver, and crystal on it. It romances the imagination and pulls you out of the everyday malaise that visits us all.

For a garden-party table setting that I styled for designer Mary Taylor McGee in Palm Beach, Florida, at a Mediterranean-style house designed by legendary architect Marion Sims Wyeth and owned by Marjorie Merriweather Post before Mar-a-Lago was built, the formal architecture and landscaping prompted me to incorporate both formal and irreverent elements into the tablescape (see pages 62–63). Presided over by a ceramic cockatoo, ornate silver objects mingle with colorful glassware and dishes; a starched, embroidered white linen tablecloth provides an elegant, restrained foundation for the riot of color on top. Foraged fuchsia bougainvillea meanders down the table, a creeping vine ready to embrace the party's guests. Mottled, imperfect oranges act as a kind of visual punctuation mark. Not everything on a dining table need be useful. Decorating a table, for me, is no different from decorating a room. All the elements that go into the mix of a successful room—oppositional colors, patterns of varying scale and origin, and a dialogue between wild and civilized—can transform a tablescape into a setting you don't want to leave.

Toeing the line between inside and out and breaking down the boundaries between the cultivated and the wild imbue any environment with a kind of magic.

OPPOSITE: On the Cycladic island of Folegandros in Greece, a windswept terrace at the country house of Simone Ciarmoli and Miguel Queda elicits Iliadic dreams. To bring the terrace to life, I brought out a pair of Chinese chairs, simple black pottery, a splash of orange to complement the blue sky, and the couple's dachshund, Gildo. A pair of amphora-like pots draw your attention to the horizon.
PHOTOGRAPHER: Ricardo Labougle

OVERLEAF: A favorite shoot of my career, this estancia outside of Garzón, Uruguay, formerly owned by Eva Claessens and Kris Ghesquière, had a small boathouse that had been turned into an office. The otherworldly romance of the place needed little intervention, aside from some foraged greenery and asymmetrically arranged books and objects.
PHOTOGRAPHER: Ricardo Labougle

PAGES 68–69: A resplendent perch with a view of Roquebrune-Cap-Martin at the home of John-Mark Horton. I set a table in a garden that was once a favorite of Grace Kelly's.
PHOTOGRAPHER: Ricardo Labougle

Flowers
FOR LIVING

Growing up in New York City, I never paid flowers much mind. My mother was an enraptured, passionate gardener at our summer house in Maine, and she'd bring in cut blooms to create lavish and lush arrangements in antique vessels and pots she'd gotten from my grandmother or sourced antiquing. Though I wasn't interested in her gardening endeavors, I was interested in the way her arrangements brought softness, beauty, and energy into the house. Today, the first whiff of lilac each spring takes me back to childhood, with an entire summer set to unspool before me and the intoxicating scents of my mother's garden wafting through the windows of our country house.

Thus, I come to floral design through the lens of interiors and the purpose that flowers so beautifully serve indoors. They can enliven, soften, energize, romanticize, and reinforce the sentiment of a room. Their ephemeral nature is part and parcel of their charm.

Because I've never trained as a florist, I think about flowers intuitively, emotionally, and in reaction to their intended environments. As I explained in "Color Theory," color is an essential way to think about styling a space: do you want to lean into a room's color or do you want to contrast it? Flowers are an ideal

OPPOSITE: In the primary bedroom of Wesley Moon's Park Avenue apartment, I opted for a fanciful but strange arrangement to converse with the baroque design of the textile panels in the elaborate headboard.
PHOTOGRAPHER: Pernille Loof

"ONE ARRANGES FLOWERS AS THE SPIRIT MOVES YOU; TO OBEY SOME INNER
PROMPTING TO PUT THIS COLOUR WITH THAT, TO HAVE BRILLIANCE HERE, LINE THERE,
A SENSE OF OPULENCE IN THIS PLACE OR SPARSENESS IN THAT; TO SUIT
YOUR SURROUNDINGS, YOUR MOOD, THE WEATHER, THE OCCASION. IN A WORD,
TO DO AS YOU PLEASE, JUST AS, IF YOU COULD, YOU MIGHT PAINT A PICTURE."

—CONSTANCE SPRY

instrument for either objective. Flowers also serve as sculptural works of art; they can reinforce the mood of a room, or they can disrupt it. Floral design is a way of expressing something about the very space in which an arrangement sits.

I anthropomorphize flowers. Each flower has one of four distinctive personality traits: bold and showy like peonies or dahlias; wispy and independent like Queen Anne's lace or cosmos; architectural and eccentric like poppies or eremurus; or wild and exuberant like clematis or sweet pea vines. Humanizing flowers helps me determine how to use them, whether in concert with one another or as independent entities. Though I often mix flowers from these various personality groups, I usually don't include more than one flower personality in the same arrangement. For example, I wouldn't use two bold flowers together in the same pot, like a dahlia and a peony. They would fight for attention. Rather, I prefer to take a showy flower and mix it with an eccentric one and add a little wild weed. Separating flowers by personality type helps you mix them to vary scale, texture, and emotion. Just as I style other elements in a room, I like to style flowers asymmetrically. I eschew tight or constrained arrangements—flowers are living beings, after all—and I always strive for movement. The eye should move across a flower arrangement just as it moves about a room.

OPPOSITE: An explosion of foxglove and ammi dara in shades of purple enlivens a country living room designed by Virginia Tupker.
PHOTOGRAPHER: Frank Frances

OVERLEAF: In a living room designed by Billy Cotton, I took inspiration for the floral bonanza in front of the fireplace from a Horst photograph of the Brandolinis' Left Bank apartment. I used the colors in the Zuber wallcovering as my guide.
PHOTOGRAPHER: Simon Watson

PRECEDING PAGES LEFT: Echinacea erupts like fireworks in this arrangement in designer Stefanie Scheer Young's Maine barn.
PHOTOGRAPHER: Read McKendree

PRECEDING PAGES RIGHT: Thrown together in a bedroom by Ferguson & Shamamian, cosmos, foxglove, garden roses, and clematis retain their individual personalities.
PHOTOGRAPHER: Thomas Loof

ABOVE: Acid-yellow parrot tulips and blush peonies vividly complement each other in a room designed by CeCe Barfield.
PHOTOGRAPHER: Lesley Unruh

OPPOSITE: A jubilant bouquet of peonies, poppies, foxglove, and nasturtium in a living room designed by Victoria Hagan.
PHOTOGRAPHER: Pernille Loof

OVERLEAF: For a sprawling floral installation at the Bernd Goeckler design store, I used jasmine vine, aubergine fritillaria, sweetly hued ranunculus, and tulips.
PHOTOGRAPHER: Douglas Friedman

"THE FLOWERS DIDN'T HAVE TO BE DAHLIAS AND ROSES EITHER,
BUT JUST THE WEEDS BLOOMING IN THE FIELDS, THE DAISIES AND THE YARROW."
—WENDELL BERRY

For the living room of a Victoria Hagan project on Martha's Vineyard (see page 79), for example, I chose flowers from each personality type to create a jubilant bouquet that evoked the vivid tones of a bright summer morning. I wanted to summon the emotion of a sunny June day in a vase. Peonies, poppies, foxglove, and nasturtium are each their own archetypes; thrown together in a single vessel, they show who they are by being in contrast to those who they are not. This arrangement moves like a dancer across a stage; textures and colors collide in joy and individuality.

A single flower type or color block can act as an equally powerful element in a space or as a way of highlighting an object. In a neoclassical porphyry cachepot from the collection of Hubert de Givenchy, I created an arrangement of cream tulips that coil, Medusa-like, from the mouth of the pot (see page 84). I wanted to evoke classical mythology in a nod to the actual object and its historical references. I also wanted to contrast the pot's shape and color by having something wild and living explode out of its stately, venerable presence.

Location is so important; be true to where you are in the world, to what grows outside and at a given time of year. Always pay homage to place. The only exception I make to that rule is in a big city like New York; the world arrives in big-city flower markets, and with little to no garden space, I think anything can and should go. But in the spring, summer, and fall, or in a tropical locale, a stroll along the road or tree line, shears in hand, is a must. Some of my favorite arrangements have been made after walks in previously unknown environments: a field of sweet pea vine adjacent to a Michigan highway, a crop of wild delphinium on a dirt road in Oregon, and a jumble of pink queen's wreath climbing up wire fences in Mexico have not only yielded extraordinary arrangements but also anchored the rooms they adorned to their place in the world. That is a singularly wonderful thing.

OPPOSITE: To highlight the proportions of this wonderful room in Lauren McGrath's 1804 Colonial home, with its giant hearth and low ceiling, I used tall grasses that brush the ceiling. I wanted to lean into the mural of a landscape, for which the grasses act as an extension. An arrangement of mid-century vessels on the mantel similarly play with scale and pattern, and a mix of chair styles keeps it interesting.
PHOTOGRAPHER: William Waldron

ABOVE: Cream tulips coil out of a neoclassical porphyry cachepot from the collection of Hubert de Givenchy.
PHOTOGRAPHER: Ethan Herrington

OPPOSITE: In the home of Suleika Jaouad and Jon Batiste, I leaned into simplicity and tonality.
PHOTOGRAPHER: Frank Frances

OPPOSITE: A foraged arrangement of lilac and dogwood in a Laird Gough porcelain vessel is a beautifully asymmetrical foil to the grid of windowpanes behind it and a celebration of the Virginia spring.
PHOTOGRAPPHER: Kelli Boyd

OVERLEAF LEFT: For this rosy-hued oceanfront living room in Sayulita, Mexico, designed by Summer Thornton, we foraged a variety of palms by wielding a machete on a jungle walk. I cut the wild pink queen's wreath from the fence of an abandoned property for the arrangement on the coffee table.
PHOTOGRAPHER: Annie Schlechter

OVERLEAF RIGHT: In a historic Hudson Valley home carefully restored by Ferguson & Shamamian, a sinuously sculptural apple-blossom branch disrupts and intercepts the linear formality of the mantel on which it sits.
PHOTOGRAPHER: Pieter Estersohn

SPRING

AWAKENING

COLORS: CHARTREUSE, YELLOW, PALE PINK, GREEN

FLOWERS: BLOSSOMING BRANCHES: DOGWOOD, FORSYTHIA, LILAC, APPLE AND CHERRY BLOSSOMS

COLLECTING THEME: PLATES

When we bought our house in rural Dutchess County in upstate New York, it was an uninhabited shell of an eighteenth-century barn with neither running water nor heat. Nevertheless, we loaded a mattress into our car and made our way north from New York City to spend our first night at the house. It was late March, and we slept on the floor in the living room under blankets in front of the fireplace. The next morning, I awoke early to the lilting, singsongy call of what I soon found out to be the red-winged blackbird, which arrives in early spring from the south.

Having always lived in a big city, this was the first time in my life that I became aware of the subtle changes in the outside world that herald the onset of a new season. Now, when I hear the red-winged blackbird's call, I know that spring is being ushered in, no matter what the snow and mud on the grizzled ground lead me to believe. There is a kind of magic in finding seasonal patterns in nature that are predictive and signal change before it is noticeable. Just as the seasons quietly change around us, so, too, does the way we live in our homes.

The first thing I did in the Barn that March was unpack my collection of plates, which had long been relegated to any protected empty space available in our apartment. I unearthed them from under beds and dressers, and now I stacked them in towering structures of various heights, like a city skyline, in the glass-fronted kitchen cupboards. I've noticed that I ritualize this task every spring; I suppose it is my answer to spring cleaning. I do most of my entertaining in the summer months, and I love to reshuffle my plates before the season starts. Reordering your belongings prompts you to see them anew.

I've been collecting plates for as many years as I've been out of my parents' home. I got the taste for them, as is the case with so many of my decorative inclinations, as a child, though my taste is different from that of my grandmother or mother. I have inherited some, but mostly I have found them. I scour auctions, flea markets, and antiques stores. My eyes are always open. I look for patterns that I haven't seen before or that have an interesting color combination, but mostly I look for things that speak to me. A single plate hung on a wall can suffice as something to revere. I wonder about who meticulously hand-painted them or who designed the transfer motif. I wonder about whose tables they rested on, who may have eaten from them. I wonder about how they came to America. Each plate is really a little tableau that tells a story about a time in history—about innovation, craft, economics, and culture.

As spring approaches, I start to change the color palette of the house. I move toward yellows, pinks, greens, and chartreuses—hopeful, naive colors. I store away my crimsons and aubergines. Merely altering the colors of accent textiles—draped over chairs, on the backs of sofas, and always over tables—instantly changes the mood of a room.

The greatest joy of spring, of course, is new life unfurling from the winter-weary ground. Spring is the most restless of seasons, when being indoors has worn out its welcome, and we thirst for light and air and anything green. As the days grow longer and the buds on the tree branches give way to frothy, diminutive blossoms, I head outside to clip limbs long and languid, and laden with pink and white blooms. *Muscari* (grape hyacinth), tulips, and pedestrian daffodils pop up as shocks of color from the desolate ground. Ostentatious forsythia dances like a fire across the countryside, its branches fit for a dramatic, tempest-in-a-teapot-like arrangement. By the end of the season, lilacs, the headiest of blossoming trees, flood the yard and waft, like an uninvited but incredibly welcome guest, through the windows. It reminds me of my childhood. Life returns to the interior.

PRECEDING PAGES AND OPPOSITE: In the diminutive hallway leading to our guest room, I often use oversize branches, like this forsythia, for dramatic proportional contrast. Playing with scale—like placing something large in a confined area—can expand the feeling of the room and provide a sense of surprise. I also play with pattern here in the massing of blue-and-white English, Dutch, French, and American ceramics (both antique and contemporary), which I have hung on the walls and arranged on the table, giving this small space a theme that distinguishes it from the larger rooms it separates.

OVERLEAF: An ornate Farrow & Ball damask wallpaper based on a ca. 1793 document lines the guest bedroom. A simple, white, Shaker-like four-poster bed from Ikea pulls the room away from the precious and provides a frame for a Kalamkari tree-of-life bed hanging by Pitchuka Srinivas for Les Indiennes. Creating a dialogue between different design traditions—in this case, block-printed paper from England and block-printed cotton from India—generates dynamic energy.

PRECEDING PAGES: The pink textile draping the table is actually a pair of luscious silk curtains that once embraced windows in my great-grandparents' house. The vase is by my friend Laird Gough. I'm always looking for ways to repurpose things; textiles are especially nimble friends in this regard and can have a transformative effect with minimal effort.

OPPOSITE: This bathtub often acts as a giant bucket for my latest floral forage.

OPPOSITE: In the dining area of the living room, I've created a pattern dialogue between the Uzbek ikat robe hanging on the wall, the slipper chair covered in a silk ikat from Le Manach, and the tablecloth from Cowtan & Tout. The conversation between these three different textiles moves the eye about the space.

ABOVE AND OVERLEAF LEFT: My daughter's room is like a verdant tree house. The hill outside her window is covered in lilac trees—heaven "scent" come May! I picked the Cole & Son Great Vine wallpaper to emulate the feeling of being in a tree, rather like a bird. It is an example of blurring the boundaries between inside and out, between tame and wild.

OVERLEAF RIGHT: If I were to suffocate in lilac, I would die happy.

PAGES 110–11, PRECEDING PAGES, OPPOSITE, AND ABOVE: I treasure the glass-fronted china cabinets in my kitchen. Unbelievably, I have run out of room, but that hasn't stopped my plate-collecting habit. Plates are wonderful objects to collect, not only because you can enjoy looking at them (I have them hung all over my house) but also because you can use them every day. I arrange my cabinets somewhat like a city skyline; instead of grouping dinner plates, dessert plates, and so on, in separate sections, I stack all kinds of dishware of varying heights and colors to create a landscape to look at. If the interior of your cabinets is visible, consider arranging their contents as you would any other space in your home, taking into account scale, color, and pattern.

OVERLEAF AND PAGES 118–19: Confessions of a plate hoarder.

SUMMER

ABUNDANCE

COLORS: BLUE AND WHITE

FLOWERS: FOXGLOVE, SCABIOSA, QUEEN ANNE'S LACE, EREMURUS

COLLECTING THEME: VASES AND POTS

The gloriously long days of summer always feel boundless with possibility. The way we live at home changes dramatically; the living room is often a space we simply pass through in the summertime, and hours spent indoors are largely nocturnal: windows open, screens in place, listening from under the sheets to the chorus of coywolves, insects, and frogs harmonizing in a cacophony of sounds. When we first moved in, we built a teahouse; it's a square platform room with screened walls situated at a remove from the house, large enough for napping, reading, dining, and entertaining. We should have dubbed it the summer house, as it is where we take up residence from June until September, and even early October, if we're lucky to have some warm days.

Instead of an outdoor sofa, I found a wrought-iron bed at auction; its elaborately scrolling headboard reminds me of the over-the-top abundance of summer, and it serves as the perfect spot for languishing throughout the summer months. There is little better than accidentally falling asleep on it on a hot afternoon. I love watching the sun set in the fields just beyond the teahouse, the sky a vaporous canvas of sherbet pink, purple, orange, and blue. Seen from afar, candles ablaze after the sun has set, the room is a veritable midsummer night's dream, with the fireflies holding court.

Though I usually don't find the combination of blue and white all that interesting inside, I love the coolness and simplicity of it in summer, especially in the teahouse, which blurs the line between indoors and out. The landscape is so full of lush things to absorb with one's eyes that I don't like to detract from it with styling. Simple Indian block prints on lightweight cotton suffice. Fussiness has no place in the summer heat.

It is my garden beds that hold my attention and excitement throughout the summer, and each year I like to experiment with something I hadn't tried the year before. I usually take cues from the things I find in the flower market and love to work with. Some of these experiments are successful, like a sprinkling of Iceland poppy seeds, while others fail, such as the Dr. Seuss-ian eremurus (though I'm going to try again in the future). Peonies usher in the season; resplendent dahlias close it. Just as in my flower arrangements, I grow flowers of varying personalities and persuasions, as I discuss in "Flowers for Living." And I embrace a riot of color. It is simply the best to be able to wander outside, cut a bounty of summer blooms, and arrange them in a vase.

Of course, summer is also the time for weeds, which hold a special place in my heart. The unsung, unattended treasures that flourish with no oversight or care are often my favorites. There is so much beauty to be had simply by paying attention to the landscape as it orchestrates itself. A roadside ramble before breakfast yields frothy, strange, and beautiful things, especially Queen Anne's lace, which I have also taken to planting in my beds alongside all my cultivated blooms, like my beloved foxglove.

I put all my pots, vases, and other vessels to good use, which is one of the best parts of the season. I collect ceramic and glass vases, from seventeenth-century Delft ginger jars to the work of contemporary ceramic and glass artists. I love vessels for their dual role at home; I group and arrange them in relation to each other, finding a dialogue between them and beauty year-round, with or without the adornment of flowers. In summer, of course, their usefulness comes into full focus. Far too little attention is paid, I find, to the importance of using the right shape of vase for the arrangement that the amateur florist wishes to create; the size and pitch of a vase, along with its shape and mouth opening, determine the success of your arrangement. A sampling of arrangements in an assortment of my vessels on pages 158–61 illustrates this important principle.

There is wonder in planting something one year and seeing it flourish the following summer, and the summer after that. It becomes part of the story you share with your land. My daughter now has her own little garden bed in the erstwhile grain silo adjacent to the Barn. She brings her little pair of children's scissors and cuts her own cosmos; we make little bouquets for her bedroom. My son tries to emulate me, lifting the watering can, which is nearly the same weight as he is, and turning it upside down to water the geraniums. These memories linger in my mind long after the first frost.

PAGES 124–25: The flower bed where I grow most of the flowers in my arrangements.

PRECEDING PAGES: View of a foggy summer morning from the guest bedroom.

OPPOSITE: In the mudroom, with mint-green walls to match the windows, I wallpapered the ceiling in an archival geometric pattern from Brunschwig & Fils. I chose a Fermoie fabric in a slightly off shade of blue for the skirt that conceals storage near the ceiling and to cover the bench cushion because it reminds me of a wildflower field. We built this room only recently, and I wanted it to match the feel of the rest of the house, as though it had always been there. I think we succeeded, right down to the choice of colors.

OPPOSITE: Open windows and bountiful eremurus! Summer calls for simplicity; a chartreuse linen tablecloth echoes the sunny tones of one of my favorite summer flowers, and I remove other accessories from the dining table, where I often have many. The color buoys the mood throughout the room.

OVERLEAF LEFT: The windows are open, and there are flowers on every table—this is summer in the living room, where we actually spend little time come June.

OVERLEAF RIGHT: In the summer months, I usually arrange my flowers outside (it makes clean-up easier!), like here on the top of the Barn's erstwhile silo, which I have turned into a little garden bed for my daughter.

PAGES 134–35: Our bedroom tells multiple color stories, with pink as the primary color protagonist. In this vignette, it's all about cobalt blue and pink. English transferware mixes with a bowl my father bought in Tehran when he lived there before the revolution. A blue Matisse cut-out somehow reminds me of the portrait of my grandmother on her wedding day.

PRECEDING PAGES LEFT: I love this convex-mirror view of our bedroom (you can see our dog Gringo sleeping on the rug). It reminds me of Jan van Eyck's *Arnolfini Portrait.*

PRECEDING PAGES RIGHT: This oversize arrangement of phlox and Queen Anne's lace brings the outdoors in, as though the field outside our window has trespassed into our bedroom. Summer is my favorite time of the year for weeds; pay attention to the untamed and uncultivated species that pop up all around you. There are many weedy treasures to be brought inside.

OPPOSITE: A Manuel Canovas fabric mimicking a verdure tapestry echoes the surrounding countryside. The blue floral headboard is from my childhood bedroom, where the walls and curtains were in the same fabric. A mix of Porthault and Tulu linens cover the bed. I picked out the Frances Palmer pitcher from her Connecticut studio-barn. Come winter, the hanging reminds me that summer's warmth and abundance will return.

OVERLEAF: Bedroom details.

OPPOSITE: Pink is an interesting foil for so many colors, resulting in a whole range of moods. I am especially fond of pink and red together. This particular pink is a vigorous shade from Farrow & Ball called Nancy's Blushes. The settee was in the library of my grandparents' home. I upholstered it in a vintage damask on the reverse that came from a bolt of fabric from the 1940s that my grandmother had kept. The Uzbek ikat robe hanging above the settee is such a delicious exploration of jewel tones and in such contrast to the pink walls that I wanted to be able to look at it from my bed. I also relish the tension between the fanciful damask and the more bohemian spirit of the ikat.

OVERLEAF: I've been collecting Italian, French, and English bird prints for our bathroom; it's like a little aerie in there. The blue vase is another piece of pottery that my father found in Iran. Opulent, frilly silk curtains are in contrast to the enormous, rustic, hand-hewn beams. A graphic kilim adds further complexity but ties in the colors of the curtains, ceiling, and bathtub. Bathrooms should feel like proper rooms with decorative concepts of their own, not merely utilitarian spaces.

PAGES 146-47: A trellis fabric from Sister Parish beautifully conceals shelves filled with toys, books, and clothing in my daughter's room. The hand-painted lampshade from Voutsa is one of several in the room.

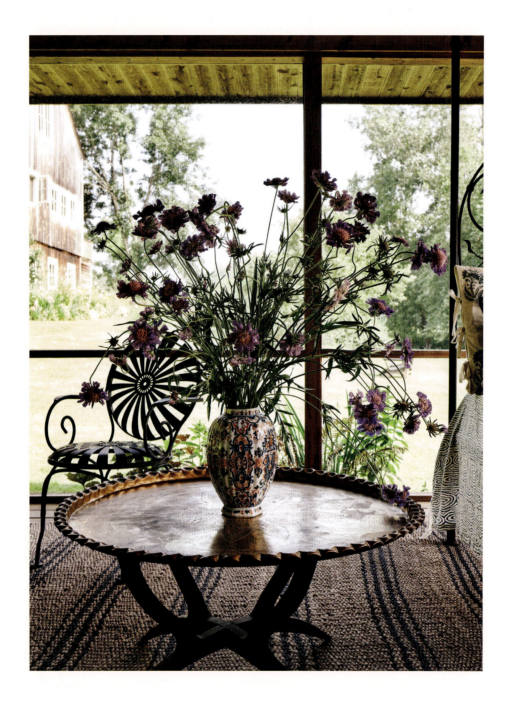

ABOVE AND OPPOSITE: In the teahouse, a Dutch ginger jar holds an explosion of Scabiosa. The wrought-iron bed, a favorite auction find, is covered in a simple but diverse mix of blue-and-white patterns from Les Indiennes and Tamam. Though everything in the teahouse is simple and useful, I still decorated it like an interior room. Treating exterior rooms like interior ones brings a civility and elegance to the outside world.

OVERLEAF: A table set for a summer dinner party features an antique embroidered tablecloth, Gregory Parkinson block-printed napkins, and Ginori plates. On every outdoor dining table I set, I go to the extra effort of using plates and linens I love, even if they're fragile. It is an instantaneous way to make entertaining outside feel special.

PRECEDING PAGES, OPPOSITE, AND ABOVE: For an alfresco lunch, I covered the table with a Lisa Corti tablecloth that embodies the vivid colors of the garden and flower arrangement. I paired my beloved Victorian wicker bench for two with green spring-seat Sunburst chairs—shockingly comfortable! I often mix varieties of chairs at dining tables, both indoors and out. A lineup of the same chairs can feel regimented, whereas mixing seating can relax a dining table's mood and interest the eye.

OVERLEAF: This outdoor table setting is my midsummer night's dream and is the essence of living in the duality between wild and tame. A clearing in a field of wildflowers and weeds begs for a cultivated foil; I oblige with linen tablecloth and silver candelabra. Decapitated dahlias make an impermanent centerpiece—a metaphor for summer itself.

ABOVE: A glass vase with a small neck and a dainty silhouette allows for a big-faced flower and a vine to mingle beautifully.

OPPOSITE: Remember: tulipières aren't just for tulips.

OVERLEAF: In flower arranging, the mouth size of the vase is everything. Flowers with wispy stalks like Scabiosa, for example (page 161, bottom right), need a narrower mouth to keep the structure of the arrangement intact. For flowers with stronger stalks, like lilies and zinnias, a wider mouth works, as long as there is a pitch to the vase. A wide body accommodates multiple stems without crowding. Flower arrangements, like people, always go through an awkward phase. Just when you think you're messing it up, I advise you to push past the awkwardness and keep adding to your arrangement. It's incredible how each flower builds upon the last, resulting in a wholly original and beautiful creation.

PAGES 162–63: An aerial shot of a hazy summer morning at the Barn.

FALL

HARVEST

COLORS: AMBER, AUBERGINE, JEWEL TONES

FLOWERS: DAHLIAS, ZINNIAS

COLLECTING THEME: CUSHIONS AND TEXTILES

There is a moment in September when the quality of light shifts ever so discreetly, triggering a touch of melancholy that no other time of year does. The light of early fall is arguably the most beautiful of the year, and perhaps that sense of melancholy stems from recognizing abundance at its apex—on the precipice of decline. It's a bit vertiginous.

This might suggest that I don't care for fall or winter, when in fact I love them both. I love returning to the interior. Once again, I have a sense of migration, of reorienting myself with my rooms and the things therein. Fall offers perhaps the most interesting dialogue between the interior and exterior world; before the first hard frost, the dahlia beds erupt in color and soar in height, their stalks many inches taller than I am, their enormous lion's-mane heads so full of petals that they droop. There's such an abundance of them that I can scarcely keep up; whereas in spring and early summer I resist the temptation to cut at will, fall offers an embarrassment of riches, yielding vast bouquets of colorful fruit punch–like blooms that I plop somewhat unceremoniously in pots. I remind myself how much I will miss this bounty in a few short weeks.

In the fall, I turn to jewel-toned textiles, earnest American jacquard blankets, and graphic rugs of varied origin, which I like to drape over my dining table, channeling a Dutch master painting of a wealthy sea merchant's interior. I shuffle pillows around on sofas and chairs. I see my textiles anew, and I'm always surprised by how adding a secondary pattern on a large upholstered piece of furniture can sway the mood of a room. My favorite bergère is upholstered in a floral moiré chintz from Le Manach. It's so

perfectly pretty that I love to make it completely clash with whatever I drape on it—a black polka-dot ikat, an Indonesian batik, or an African indigo. It is what I think of as pretty things doing battle with each other. I can't stand just pretty. Pretty pleads for something to throw it off balance.

Similarly, I like to play with scale on my humpback sofa, which is covered in a brown, densely repeating Zak+Fox fabric. Based on an old document referencing both jellyfish and flowers (brilliant!), it's a lovely foil for large-repeat silk damasks and traditional suzani embroideries. My favorite nineteenth-century American blanket, which is very modern in spirit with its all-over geometric pattern, engages in an unlikely but compelling conversation with others that somehow works. It's a small example, but I think it sums up my approach: finding dialogue between the disparate to reveal something new and interesting to look at. Collecting, layering, and mixing are ways to create an aesthetic unique to one's own space. As in so many things in life, decorative or otherwise, context is everything.

Though I adore the "buds of May" in all their filigree finery, it is the changing leaves of October that I may actually prefer. Death, on a branch, is quite becoming—leaves ablaze in bright rust and ochre, sometimes forming an ombré-like pattern on a single branch in various phases of transitioning, are so dramatic that they are almost sculptural. To catch them just before they expire is like harvesting a delicacy for the eyes. I arrange them like towering spirits throughout the living room, adding chaos and beauty wherever they go.

I relish the first candlelit dinner of fall. It feels cosseting and convivial, and mostly makes me happy to be home. We make bets on when the first snow will fall.

PAGE 168: I repurposed a silk sari to use as a tablecloth for an outdoor lunch. This mix of amber, ruby, coral, and green—the hues of the dying embers of a bonfire—are the colors that make fall such a beautiful season. The canopy of river birch branches creates a secret room. A shallow serving platter, filled with less than an inch of water, is the ideal vessel for a low floral arrangement of chrysanthemums and dahlias, which spill over its sides, concealing the platter entirely.

PAGE 169: Flowers, like branches of autumn leaves, are the most beautiful when about to expire. I always leave errant petals where they fall.

PRECEDING PAGES AND OPPOSITE: The teahouse gets a seasonal textile swap for its last days of use. Interestingly, this American jacquard blanket is very similar in color to the blue-and-white summer block prints, but the heavy material completely changes the tenor of the space. The addition of suzani pillows with predominantly rust-hued motifs mirrors the changing landscape surrounding the teahouse. I will miss this room come winter.

OVERLEAF LEFT: A Greek-meets-Egyptian Revival mirror in the mudroom, with gilded sconces to hold tapers. A voluminous arrangement of Fire Light hydrangea, *Heptacodium*, and *Nicotiana* in an amber Murano vase is warm and inviting, and its fall colors draw you into the new season.

OVERLEAF RIGHT: Dramatic dying branches and layered textiles signal a shift in season and mood. I look for interesting shapes when cutting branches. Seek out the sculptural and think about where it will live in your house to determine the right proportion. Remember, you can always make it shorter, but never longer!

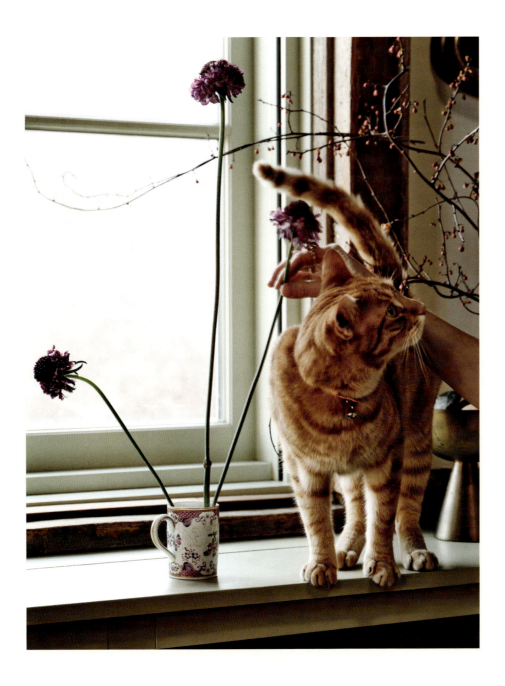

PAGES 176–77: My dahlias at their apex, right before the first hard frost. There are almost too many to harvest; I cut with impunity in the fall. I leave decapitated, full-faced flowers lying on tables, a beautiful curiosity. I've added some new taper candles to my Casamidy Molecule table.

PAGES 178–79: My ceramic artist friend Jeremy Anderson made a portrait of me. It's a wonderfully sculptural vessel for single, dramatic branches. Search for vessels that become permanent residents in your home and look beautiful with or without the adornment of flowers.

OPPOSITE: A rare Delft vase with a black, orange, and green floral design holds a moody, thorny arrangement.

ABOVE: The curious Roy Boy.

PAGES 184–85: An arrangement of dahlias erupts out of a luminous Murano glass vessel from Artemest. The tableau on top of my sideboard is an exercise in varying scale and textures to romance the eye. All the items, ranging from a pharaoh's-head garden sculpture to a pair of silver pheasants, are of different materials, colors, and heights. But, spaced with a sense of symmetry based on proportion, the arrangement forces the eye to wander through it, rather than be stopped by it.

PRECEDING PAGES LEFT: A profusion of pokeweed, which I love as much as my cultivated blooms. Its aubergine berries mimic the color of the liturgical velvet cloth behind it, the manganese tile on the mantel, and the dabs of purple in the Tessa Greene O'Brien painting over the mantel.

PRECEDING PAGES RIGHT: My living room, bathed in gorgeous autumnal morning light. I opted for a kaleidoscopic breadth of color here, from the opulent tones of the Le Manach silk ikat on the armchair to the sapphire-blue Pierre Frey velvet on the Orior sofa, and the muddy purple on the loveseat, picked up in the pillows. A simple Jean-Michel Frank coffee table acts as a neutral anchor.

OPPOSITE: I swap taper candles to fit the tenor of the season's colors.

OVERLEAF AND PAGES 192–93: Amethyst, chocolate, and bright orange collide; the tablecloth is by Le Manach. The cacophony of patterns is held together by a common color scheme grounded in aubergines and browns.

PRECEDING PAGES: An assortment of my varied pillows. I seem to amass them with abandon, often unsure of where they will ultimately live. In addition to musical chairs, I play musical pillows.

ABOVE: Another example of my penchant for mixing damask and ikat.

OPPOSITE: Pattern play at work: here I mix Zak+Fox's dense, jellyfish-like floral fabric on the sofa, a geometric antique American jacquard blanket that looks positively modern, a large-scale, suzani-embroidered bolster from Cowtan & Tout, and silk pillows with bird and floral motifs from Dedar. A concise color story binds them together in a way that works despite the mix of patterns, scale, and density.

WINTER

RESPITE

COLORS: CRIMSON, CHOCOLATE, COBALT, SILVER

FLOWERS: SLUMBERING GERANIUMS, PAPERWHITES, AMARYLLIS

COLLECTING THEME: FEMALE PORTRAITS

What is it about home—a universe unto itself contained by walls, doors, and windows—that is so fascinating to me? It is surely in winter when I contemplate this the most. The ostentatious bang of Christmas and New Year's that commences each winter quickly gives way to the quieter mood that marks the rest of the season.

It is in winter when I do the most tinkering, moving paintings here and there, rearranging mantels and tabletop surfaces. It is a time to play with the objects at home and the narratives they can tell when put together in new configurations. The decorative arts have always captivated me. I have long taken exception to the notion that the decorative is thought of in the diminutive—a lesser art form than a painting or a sculpture. The skill that goes into making a beautiful object is no less than that of a painting. Should usefulness render a beautiful object less than? I have never thought so, and I would argue that decorative objects tell us as much, if not more, about history and the human condition as paintings do. But more than anything intellectual, I wonder about objects: Which rooms in which places did this object live? Who touched it? Who loved it? Why was it relinquished? This curiosity fuels my passion to collect and is the reason I surround myself with all kinds of things at home—broken manganese tiles, textile fragments, faience plates. Things speak to me—a silent but captivating conversation—and I'm always listening, my eyes for ears. Winter is a time to celebrate all the objects that make your home distinctly yours.

Of course, winter is not just a solemn affair; I love to entertain in the cold, dark months. I will move our dining table around to new locations in the living room to accommodate larger groups—for Christmas dinner or birthday parties. It's so fun seeing a room arranged just a little differently than it normally is. And though I love a densely patterned tablecloth, I also love setting a delicate white linen or lace cloth on the table, dressed in polished silver and fine, fussy plates and crystal. A fancy party in a decidedly unfussy barn once meant for hay and livestock feels right to me.

I still forage in the winter. Bittersweet vine, which my husband wars with each summer for choking our trees and bushes to death, makes for a fabulously sculptural flourish even after its berries have shriveled to little crimson droplets. For Christmas, I chop down evergreen branches for large-scale and festive urn arrangements (beware the sap). I have a soft spot for traditional bulbs—potted amaryllis, paperwhites. Our geraniums come in, refugees from the cold, and they winter on our living room floor. There's something beautiful about the repetition of it all, reminding me of the temporary yet cyclical nature of all things.

One of my favorite collections is my series of "lady portraits." I spend a good deal of time in the winter looking at them. I have always been drawn to these pictures of unknown sitters, charting moments from childhood to old age. It's comforting to see the continuum. Some of them hold animals—birds, pets—some hold flowers, some write. Their garments are the only giveaway of their time on earth. Like my objects, I wonder about these forgotten ladies, their memory contained now only on canvas, hung together in my upstate New York barn. I like to think that they, too, talk to each other.

PAGE 200: A tableau of foraged evergreen and pink amaryllis is a classic and simple way to embrace the season with maximum effect.

PRECEDING PAGES LEFT: This abundant arrangement of anemones, foraged evergreens, tulips, and ranunculus in a crimson vessel anticipates the frenetic and festive season ahead.

PRECEDING PAGES RIGHT: For the amateur florist, I recommend buying these inexpensive floral buckets in various sizes. They are extremely practical, stackable, and useful.

OPPOSITE: I like to use bowls, pitchers, and other kinds of unexpected vessels to plant my paperwhites and amaryllis bulbs; they feel more personal and unusual in such containers than when planted in ordinary terra-cotta pots. I use an antique red jacquard for a tree skirt.

ABOVE: This verdigris-hued table from Corbin Cruise is a fabulous color foil not just to the rug underneath it but to any object placed on top of it, like this Delft charger and pink lusterware plate. Think about using one surprising color as a punctuation mark in a room; it adds levity and often prevents the space from taking itself too seriously.

OPPOSITE: Winter is an excellent time to take down all your art and rearrange it. The very act of moving around objects, artwork, and textiles allows your eyes to see things anew. I love the beautiful, rich blue of the François Rouan painting above the fireplace.

OVERLEAF: I think of fireplace mantels as landscapes, an opportunity to play with scale, context, and humor. In this instance, the primary color story of red and blue acts as the connector between the various objects and shapes.

PAGE 210: For parties, I like to move my dining table around to new locations. This simple change makes the room somehow more animated and fun. A white linen tablecloth—not quite perfectly pressed—lends a timeless simplicity to the Christmas table. The slipcovers on the chair seats, which I had made for multiple chair shapes, are from Arjumand's World. While I like to mix chair styles, a matching slipcover pattern unites them.

PAGE 211 AND PRECEDING PAGES: My favorite part of winter is hosting candlelit dinner parties. The candlelight makes the luster application on these Wedgwood plates sparkle, along with the silver and Baccarat crystal. Winter is about catching and reflecting light wherever possible, especially at night.

OPPOSITE: Roy Boy poses on my desk, which I got from Montage Antiques, a favorite dealer with the best treasures. The sculptural, cerused-oak lamp is by Kimille Taylor. The layered rugs—a nineteenth-century Kazak and a nineteenth-century Shiraz—are sourced from Tent.

OVERLEAF: A detail of my bookshelves, laden with design reference books, old issues of *World of Interiors*, and plenty of fiction. Interspersed are ceramics and old family photos, including a favorite of my great-grandparents astride camels in Egypt a mere two months after King Tut's tomb was discovered. The painted desk is Venetian. I've hung artwork and maps directly on the bookcases; interspersing objects and art among the books animates bookshelves.

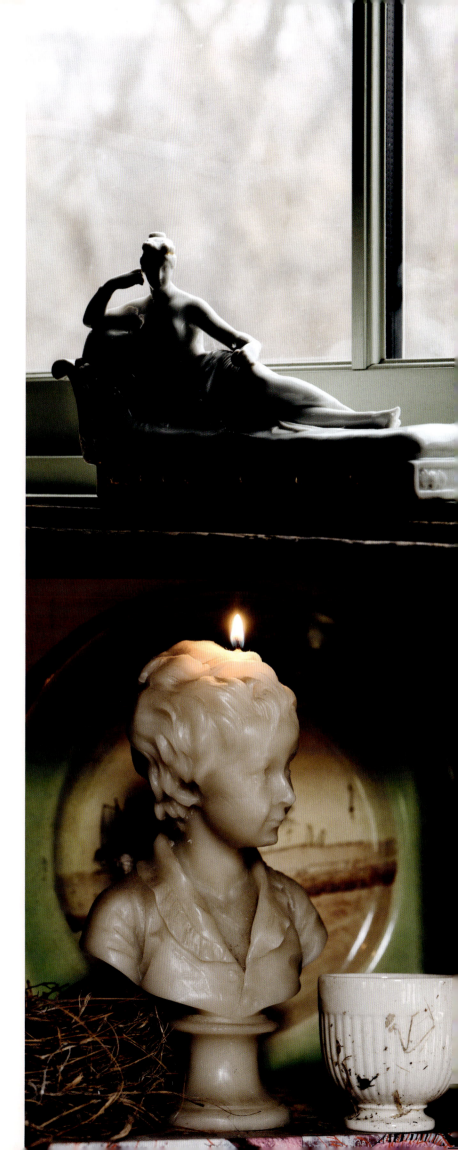

OPPOSITE AND RIGHT: Playing with scale, proportion, and materials.

OVERLEAF LEFT: I collect abandoned birds' nests from our property and place them on bookshelves and mantels. The complexity of their construction, mixed with the humbleness of the materials used, fills me with admiration and awe. I am a great bird lover and am touched by the care with which they build their nests. Nests also address a question I ruminate on: Where is the line between wild and tame?

PAGES 221–27: My beloved lady portraits, which I have sourced from everywhere. The first one I ever got is of the woman with a lamb, apparently a distant relative, which my grandmother gave me when I was about twelve. My mother kept it until I had a place of my own to put it in. My latest—and favorite—acquisitions are two late-sixteenth- or early-seventeenth-century paintings of chariot-riding women, depicted amid landscapes of Asia and Africa, respectively. I found them in L'Isle-sur-la-Sorgue, France, and had them shipped home. I love all the animals represented in them: lions, ostriches, elephants, camels, and even the slithering, alligator-like reptile that forms the arm of the chariot in the Africa tableau. A vivid crimson shocks the otherwise dim, time-worn canvases. It's fascinating to think of the painter, who most certainly had never been to either continent, taking such fantastical liberties.

PAGES 228–29: A snowy morning at the Barn in late winter.

ACKNOWLEDGMENTS

My greatest thanks are due to my co-creator and friend on this adventure, Frank Frances, whose sumptuous and artful photography elevated the entire premise of this project. Olivia DeMetros brought her exacting skills and joyful energy to each picture. The indomitable Erin Fowler, my secret weapon, keeps me on track in all things. My gratitude to the three of you is unmatched.

I am thankful to publishers Mark Magowan and Beatrice Vincenzini, whose immediate embrace and encouragement of this project humbled and thrilled me; to my editor, Jacqueline Decter, who is the real shepherd of this book, a nimble word stylist, and now a great friend; and to Rita Sowins, my book designer, whose intuitive understanding of my point of view and patience made this book sing. I thank Jim Spivey for his seamless handling of the book's production, and Meghan Phillips and Amy Tai for their tireless efforts to promote the book to the world at large. I am grateful to John Demsey and Douglas Friedman, who threw me in the path of Vendome.

This book, of course, would not have been possible without the creative minds behind all the beautiful spaces featured herein. To each interior designer and architect in these pages, I owe you a debt of gratitude for bringing me in to collaborate on your incredible work.

I have the enormous fortune to work with some of the greatest interiors photographers in the game, from whom I have learned so much and who fill my workdays with joy. Thank you for your generosity and your pictures, which make this book so luminous.

My gratitude to my floral arsenal, who cultivate and source the bounty crucial to my work, including Marilyn at Cedar Farm and the teams at Dutch Flower Line and 28th Street Wholesale.

My gratitude to John Crawford for all the invaluable help with the Barn over the years.

My gratitude to editors I have worked under who have mentored me throughout my career, including Michael Boodro and Deborah Needleman.

My gratitude to *AD*'s Amy Astley, Alison Levasseur, and Michael Shome, who have trusted me with styling projects conceived by design luminaries; I am so happy to have had the privileges you have given me, many of which are featured in these pages. Thank you.

My gratitude to friends and colleagues who have helped in ways large and small on this project, including Eliza Harris and Susan Crater, Dana Rohn, Mary Nelson Sinclair, Billy Cotton, Miry Park, Fiona West and Kim Huebner, Christina Juarez, Zak Profera, and Robert Rufino.

I am thankful to my parents, who gave me a childhood rich in experiences that shaped who I am today.

I dedicate my book to my family. This project—and all the work I do—would not happen without the steadfast support, enthusiasm, and love from my husband, Tyler Graham, and my children, Willemien and Lock—the great treasures of my life.

Interiors: Styled by Mieke ten Have
First published in 2024 by The Vendome Press
Vendome is a registered trademark of The Vendome Press LLC

VENDOME PRESS US
P.O. Box 566
Palm Beach, FL 33480

VENDOME PRESS UK
Worlds End Studio
132-134 Lots Road
London, SW10 0RJ

www.vendomepress.com

ISBN 978-0-86565-457-0

Publishers: Beatrice Vincenzini, Mark Magowan, and Francesco Venturi
Editor: Jacqueline Decter
Production Director: Jim Spivey
Designer: Rita Sowins / Sowins Design

Library of Congress Cataloging-in-Publication Data available upon request

Printed and bound in China

Second printing

BACK OF ENDPAPERS: Detail of *Pavillon de Bidaine* by Manuel Canovas.

PAGES 2–3: Summer in the teahouse: on the bed, block-printed linens from Les Indiennes and Tamam. The chairs are covered in a Madeline Weinrib outdoor fabric, and the rug is from Dash & Albert.

PAGES 4–5: A Murano vase from Artemest is filled with dahlias from the garden. The Dutch mirror is from Montage Antiques.

PAGES 6–7: The textile hanging behind the bed is a verdure tapestry-like fabric by Manuel Canovas. The headboard is from my childhood bedroom, the bolster is from Schuyler Samperton, and the jacquard blanket is antique.

PAGE 8: On a table in the entryway of the living room, an antique paisley is draped over a floral fabric from Charles Burger. A vase from Laird Gough holds autumnal branches.

PAGES 16–17: In a Chicago dining room designed by Summer Thornton, a riot of patterns abounds.
PHOTOGRAPHER: Annie Schlechter

PAGES 90–91: A foggy summer morning at the Barn.

PAGE 230: In the bedroom, a quince-filled Murano vase from Artemest stands on a coffee table covered with Manuel Canovas's *Pavillon de Bidaine* fabric. An Uzbek ikat robe hangs on the walls.